COLOUR ME GOOD BENEDICT CUMBERBATCH

Mel Elliott

Published by I LOVE MEL
ISBN 9780992777753
© M Elliott 2014

Benedict Timothy Carlton Cumberbatch is an English actor and all round top fella.

He was born in Hammersmith, London in 1976 and has acted his heart out starring in critically acclaimed films and TV series, with the immensely popular BBC drama, *Sherlock* projecting him to worldwide super stardom. Brilliant at playing nonfictional characters (Stephen Hawking, Julian Assange, Vincent Van Gogh), Cumberbatch has quickly become one of Britain's best-loved actors.

This colouring book not only lets you colour in Benedict Cumberbatch, it also lets you use your imagination and drawing skills to have a bit of fun and join in a little bit more.

There is a full filmography in the back too!

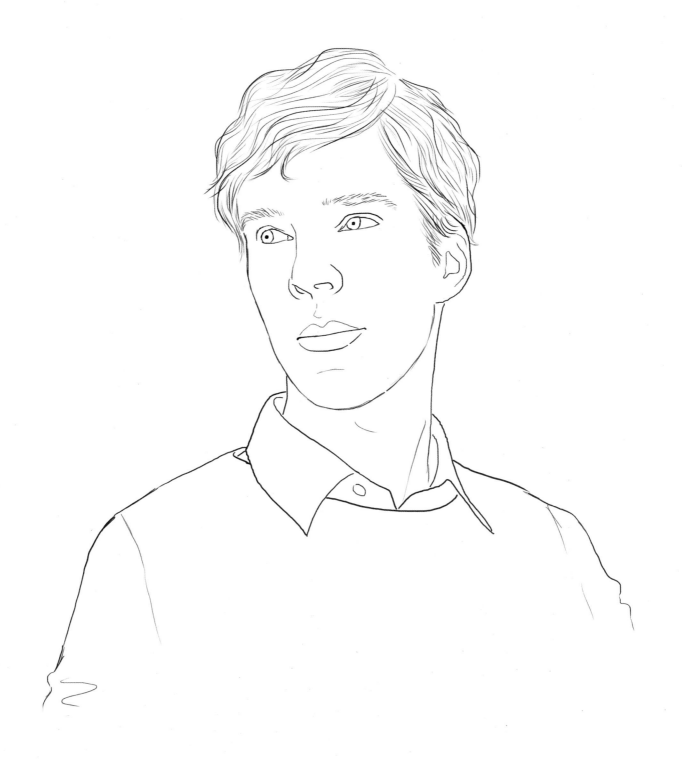

Benedict is listening to some music. Why don't you draw him a band T-Shirt to show him what you'd like him to listen to?

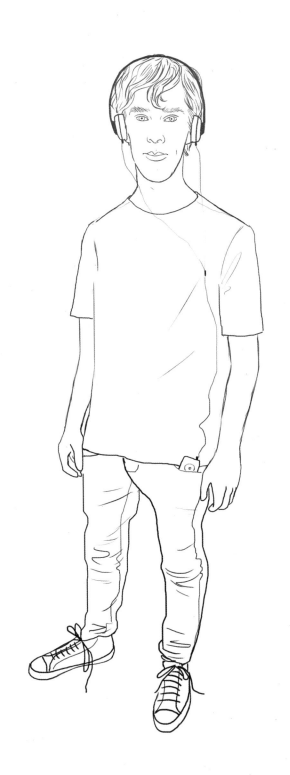

Draw a groovy pattern on Benedict's scarf.

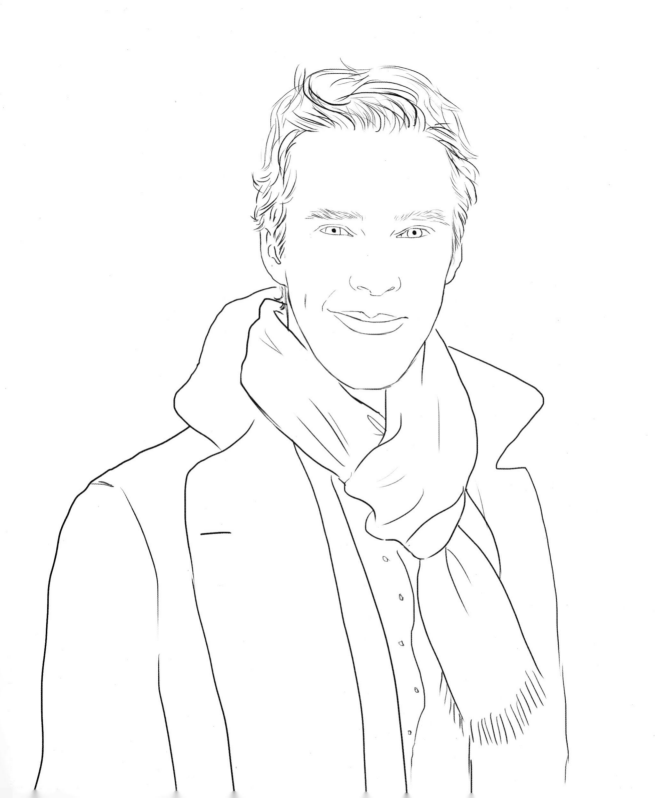

Uh-Oh!

Benedict has no date for tonight!

Why don't you draw yourself (or maybe your Nan), on Benedict's arm?

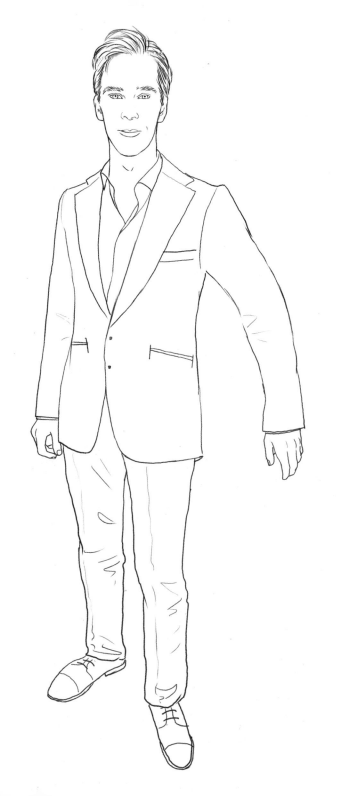

Draw Benedict a stylish and/or comfy chair to rest his bottom on.

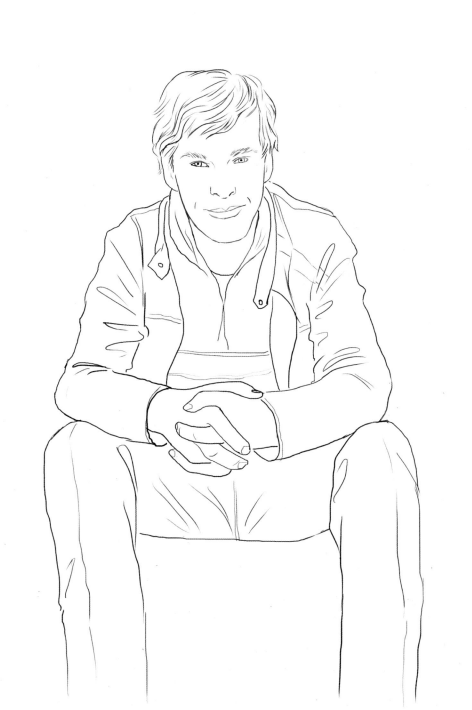

Poor Benedict is all packed up with nowhere to go. Draw a dream house for you and Benedict to share and fill with flat-pack furniture.

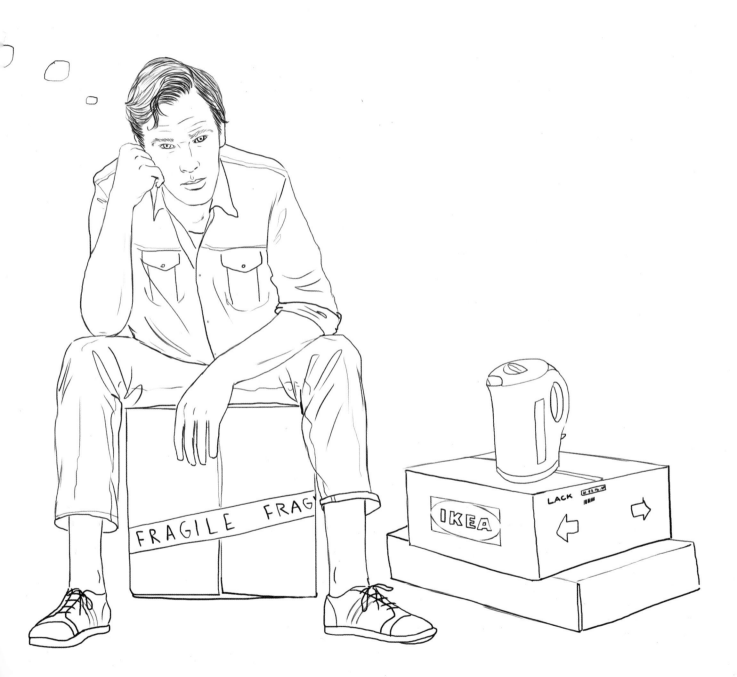

In 2004, Benedict played mega genius Stephen Hawking, in TV movie *Hawking*, directed by Phillip Martin and written by Peter Moffat.

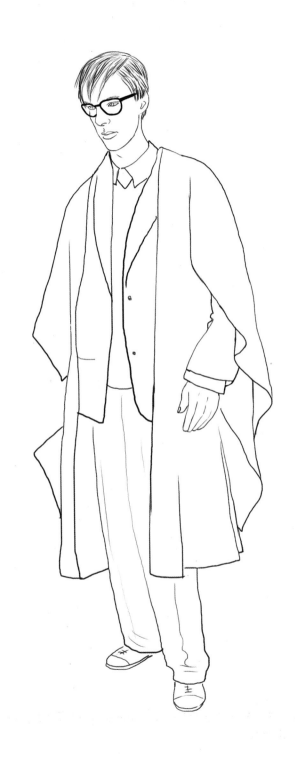

In 2013 Benedict starred as Khan Noonien Singh in *Star Trek Into Darkness*, directed by J.J. Abrams.

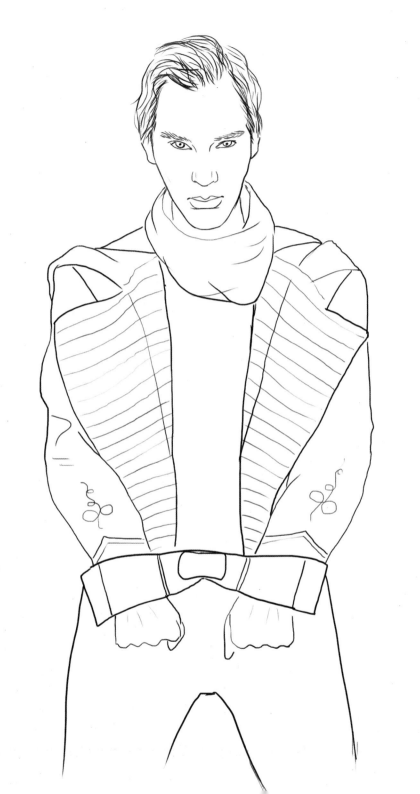

Benedict is freezing in the rubbish English weather.

Why don't you knit him a jumper and then draw it onto him?

He'd love that!

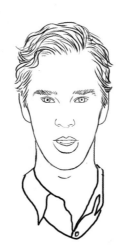

What would you like Benedict
to say to you?

And how would you respond?

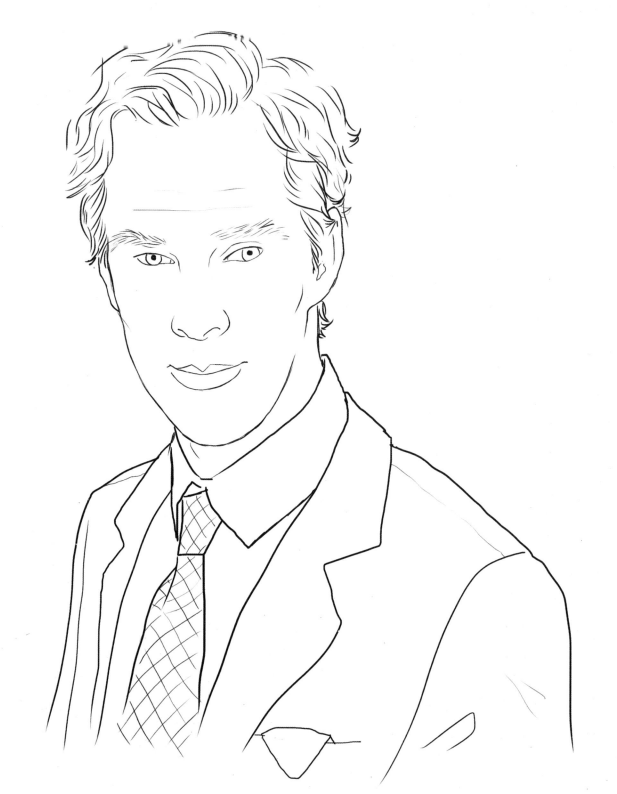

In 2011, Benedict played Peter Guillam in John le Carré's *Tinker Tailor Soldier Spy*, directed by Thomas Alfredson.

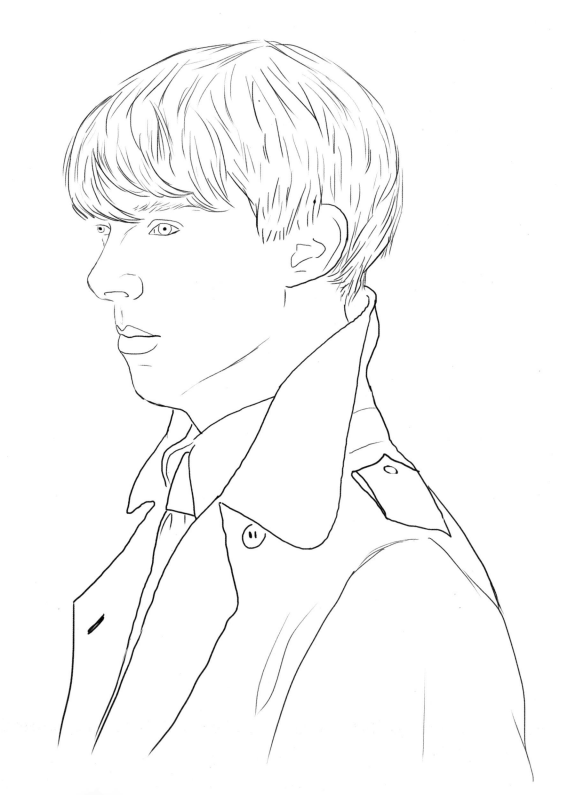

Sherlock thinks he's really clever.

Write a really hard puzzle to get the better of him!

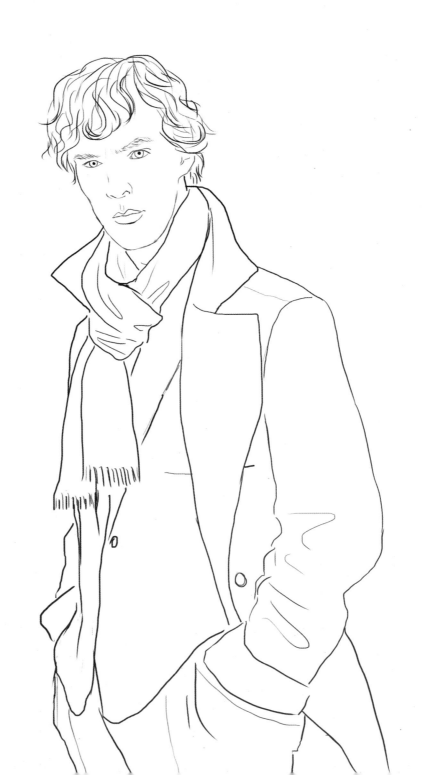

Benedict is delighted that you have cooked him a hearty meal.

Draw your creation below.

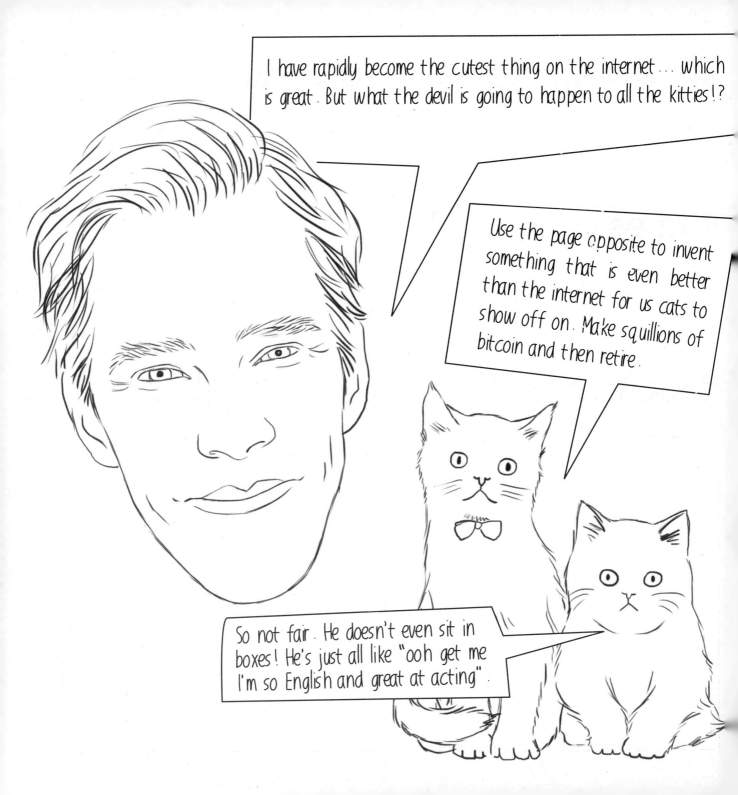

My life-changing invention is:

It does this:

It looks a bit like this:

We all loved it when Benedict photo-bombed U2 at the 2014 Oscars.

But it's time that the tables were turned, draw YOUR best photobomb and give 'The Batch' a taste of his own medicine!

Me and Benedict Cumberbatch, just hangin' out.

A triumphant Benedict has been made KING OF THE WORLD (at last)!

Draw a suitably majestic crown upon his head.

Benedict Cumberbatch Filmography

Benedict has been such a busy lad that all of his outstanding TV work wouldn't even fit on the page!

Hawking, 2004
Starter For Ten, 2006
Amazing Grace, 2006
Atonement, 2007
Stuart: A Life Backwards, 2007
The Other Boleyn Girl, 2008
Burlesque Fairytales, 2009
Creation, 2009
Small Island, 2009
Four Lions, 2010
Van Gogh: Painted With Words, 2010
Third Star, 2010
The Whistleblower, 2010
Tinker Soldier Tailor Spy, 2011
War Horse, 2011
Wreckers, 2011
The Hobbit: An Unexpected Journey, 2012
Star Trek Into Darkness, 2013
12 Years A Slave, 2013
The Fifth Estate, 2013
August: Osage County, 2013
The Hobbit: The Desolation of Smaug, 2013

If you like this, you'll love *Colour Me Swooooon*, the bumper colouring/activity book filled with 60 handsome heartthrobs (including Benedict Cumberbatch and Ryan Gosling of course!)

This and many other Mel Elliott creations are available at:

shop.ilovemel.me

**Don't forget to show me your efforts!
Twitter: @mellyelliott
Instagram: @i_love_mel**

Published by
I LOVE MEL
Printed in UK, 2014

I Love Mel is a trading name of Brolly Associates Ltd
www.ilovemel.me
©M S Elliott 2014

Distributed in the United States and Canada by SCB Distributors.
Distributed outside of the United States and Canada by Turnaround Publisher Services.